Patterning Techniques

A pattern is a repetition of shapes and lines that can be simple or complex depending on your preference and the space you want to fill. Even complicated patterns start out very simple with either a line or a shape.

Repeating shapes (floating)

Shapes and lines are the basic building blocks of patterns. Here are some example shapes that we can easily turn into patterns:

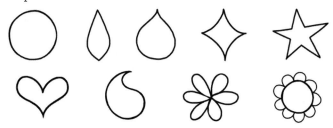

Before we turn these shapes into patterns, let's spruce them up a bit by outlining, double-stroking (going over a line more than once to make it thicker), and adding shapes to the inside and outside.

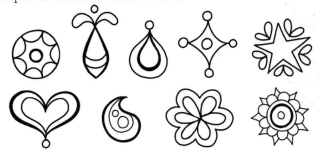

To create a pattern from these embellished shapes, all you have to do is repeat them, as shown below. You can also add small shapes in between the embellished shapes, as shown.

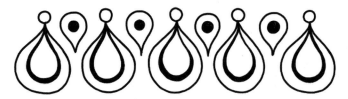

These are called "floating" patterns because they are not attached to a line (like the ones described in the next example). These floating patterns can be used to fill space anywhere and can be made big or small, short or long, to suit your needs.

Tip

Draw your patterns in pencil first, and then go over them with black or color. Or draw them with black ink and color them afterward. Or draw them in color right from the start. Experiment with all three ways and see which works best for you!

Tip

If you add shapes and patterns to these coloring pages using pens or markers, make sure the ink is completely dry before you color on top of them; otherwise, the ink may smear.

Repeating shapes (attached to a line)

Start with a line, and then draw simple repeating shapes along the line. Next, embellish each shape by outlining, double-stroking, and adding shapes to the inside and outside. Check out the example below.

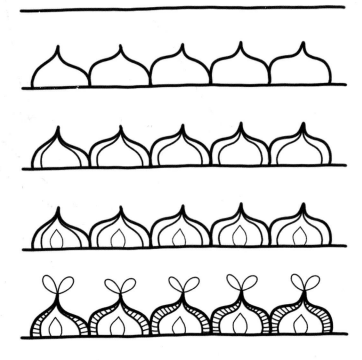

You can also draw shapes in between a pair of lines, like this:

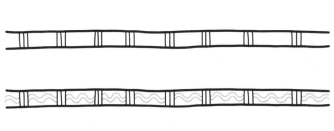

Embellishing a decorative line

You can also create patterns by starting off with a simple decorative line, such as a loopy line or a wavy line, and then adding more details. Here are some examples of decorative lines:

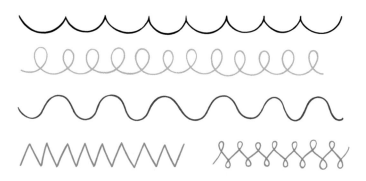

Next, embellish the line by outlining, double-stroking, and adding shapes above and below the line as shown here:

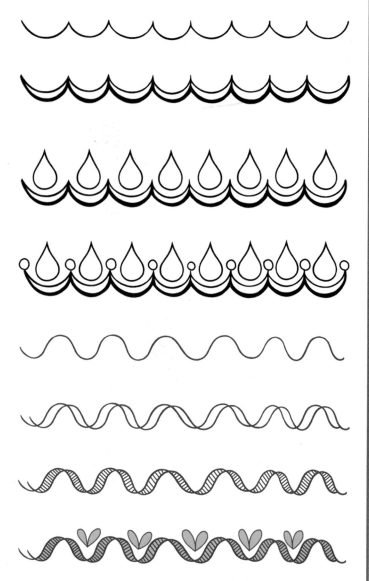

Color repetition

Patterns can also be made by repeating sets of colors. Create dynamic effects by alternating the colors of the shapes in a pattern so that the colors themselves form a pattern.

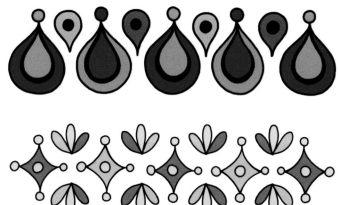

Tip

Patterns don't have to follow a straight line—they can curve, zigzag, loop, or go in any direction you want! You can draw patterns on curved lines, with the shapes following the flow of the line above or below.

These types of patterns look great when attached to the inner or outer edge of a drawing, such as the inside of a flower petal or butterfly wing.

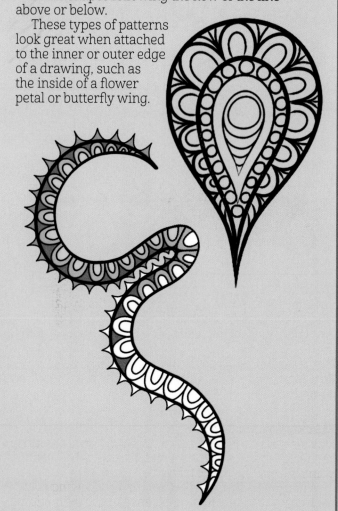

Coloring Techniques & Media

My favorite way to color is to combine a variety of media so I can benefit from the best that each has to offer. When experimenting with new combinations of media, I strongly recommend testing first by layering the colors and media on scrap paper to find out what works and what doesn't. It's a good idea to do all your testing in a sketchbook and label the colors/brands you used for future reference.

Markers & colored pencils

Smooth out areas colored with marker by going over them with colored pencils. Start by coloring lightly, and then apply more pressure if needed.

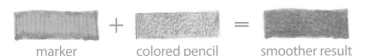

marker colored pencil smoother result

Test your colors on scrap paper first to make sure they match. You don't have to match the colors if you don't want to, though. See the cool effects you can achieve by layering a different color on top of the marker below.

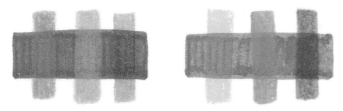

Markers (horizontal) overlapped with colored pencils (vertical).

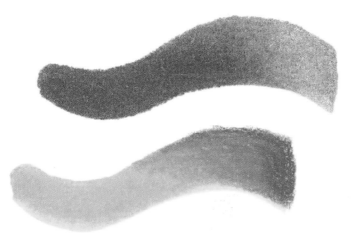

Purple marker overlapped with white and light blue colored pencils. Yellow marker overlapped with orange and red colored pencils.

Markers & gel pens

Markers and gel pens go hand in hand, because markers can fill large spaces quickly, while gel pens have fine points for adding fun details.

 White gel pens are especially fun for drawing over dark colors, while glittery gel pens are great for adding sparkly accents.

Shading

Shading is a great way to add depth and sophistication to a drawing. Even layering just one color on top of another color can be enough to indicate shading. And of course, you can combine different media to create shading.

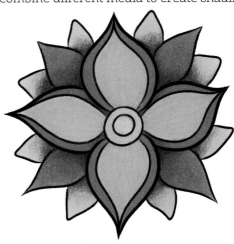

Colored with markers; shading added to the inner corners of each petal with colored pencils to create a sense of overlapping.

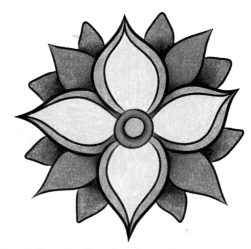

Colored and shaded with colored pencils.

Lines and dots were added with black ink to indicate shading and then colored over with markers.

Color Theory

Check out this nifty color wheel. Each color is labeled with a P (primary), S (secondary), or T (tertiary). The **primary colors** are red, yellow, and blue. They are "primary" because they can't be created by mixing other colors. Mixing primary colors creates the **secondary colors** orange, green, and purple (violet). Mixing a primary color and a secondary color together creates the **tertiary colors** yellow-orange, yellow-green, blue-green, blue-purple, red-purple, and red-orange.

Working toward the center of the six large petals, you'll see three rows of lighter colors, called tints. A **tint** is a color plus white. Moving in from the tints, you'll see three rows of darker colors, called shades. A **shade** is a color plus black.

The colors on the top half of the color wheel are considered **warm** colors (red, yellow, orange), and the colors on the bottom half are called **cool** (green, blue, purple).

Colors opposite one another on the color wheel are called **complementary**, and colors that are next to each other are called **analogous**.

Look at the examples and note how each color combo affects the overall appearance and "feel" of the butterfly. For more inspiration, check out the colored examples on the following pages. Refer to the swatches at the bottom of the page to see the colors selected for each piece.

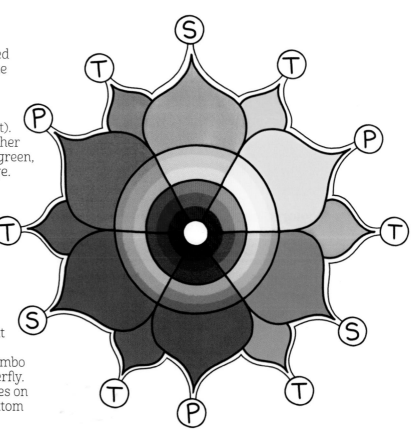

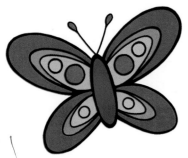

Warm colors

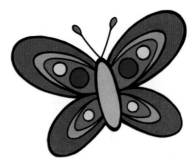

Cool colors

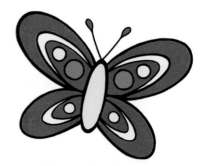

Warm colors with cool accents

Cool colors with warm accents

Tints and shades of red

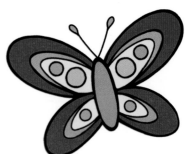

Tints and shades of blue

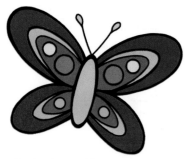

Analogous colors

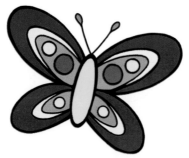

Complementary colors

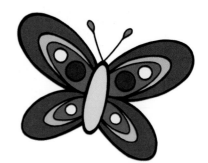

Split complementary colors

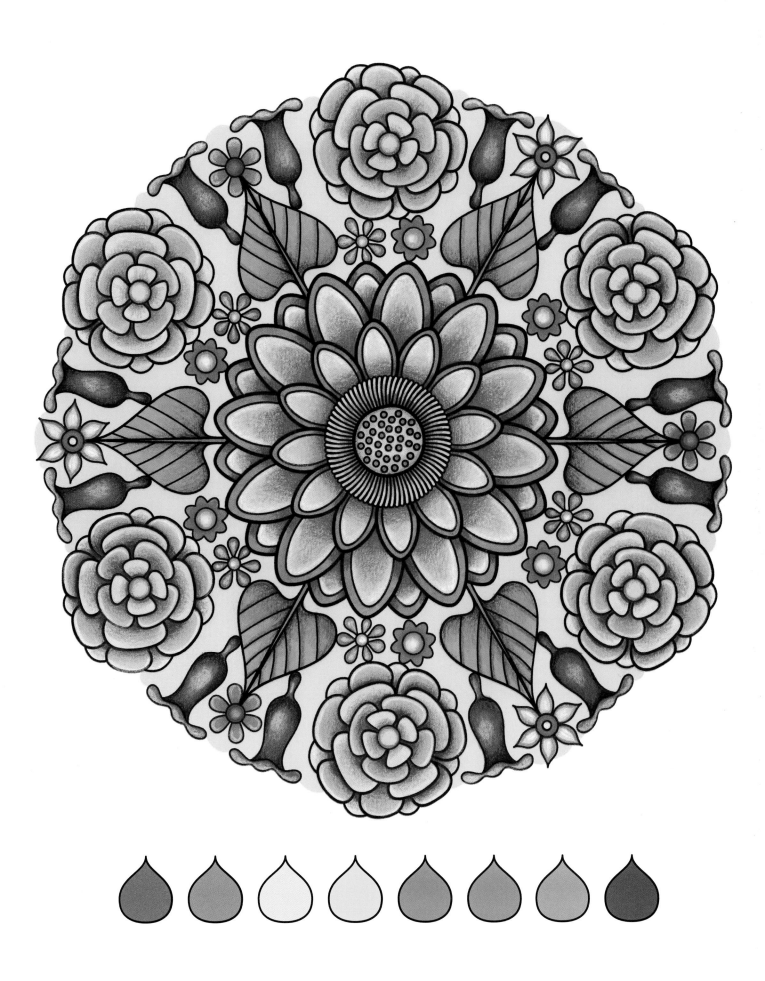

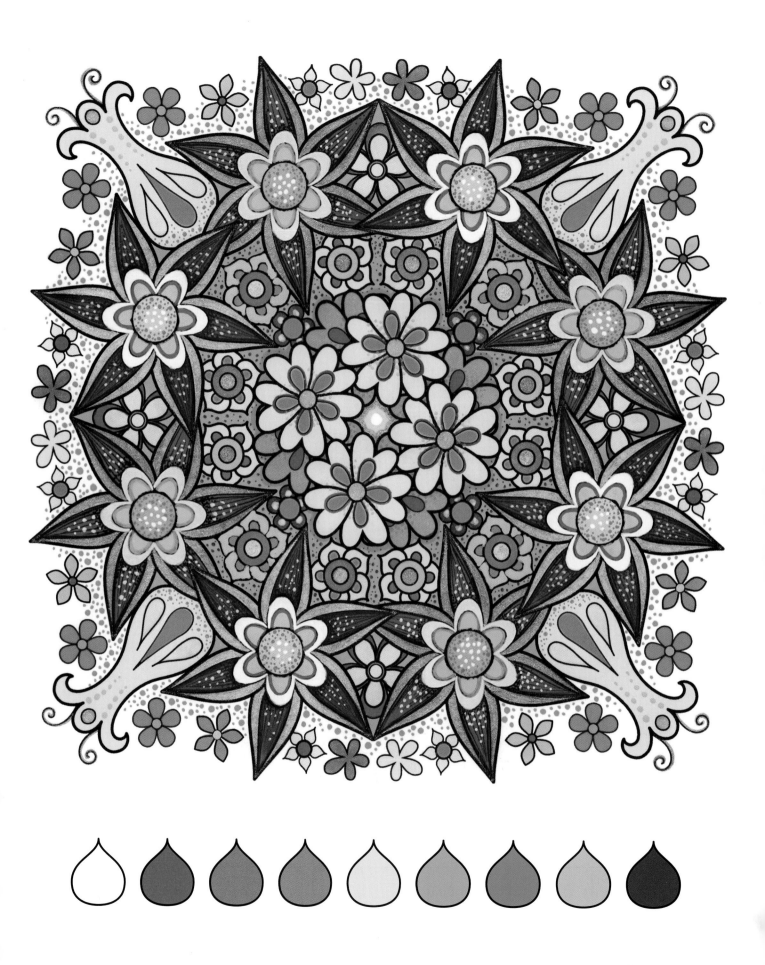

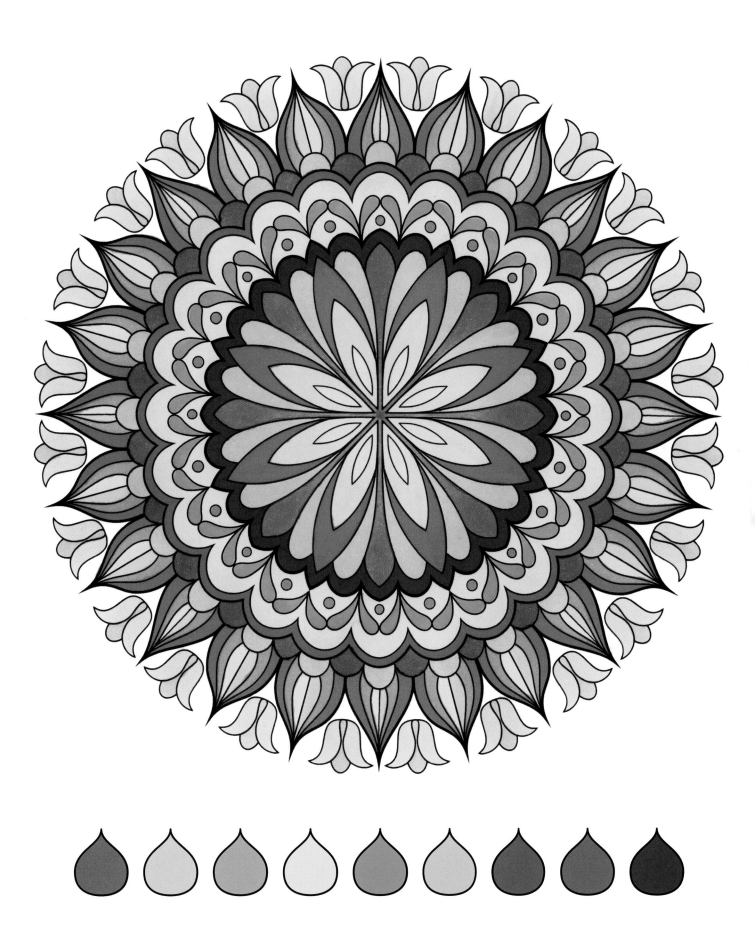

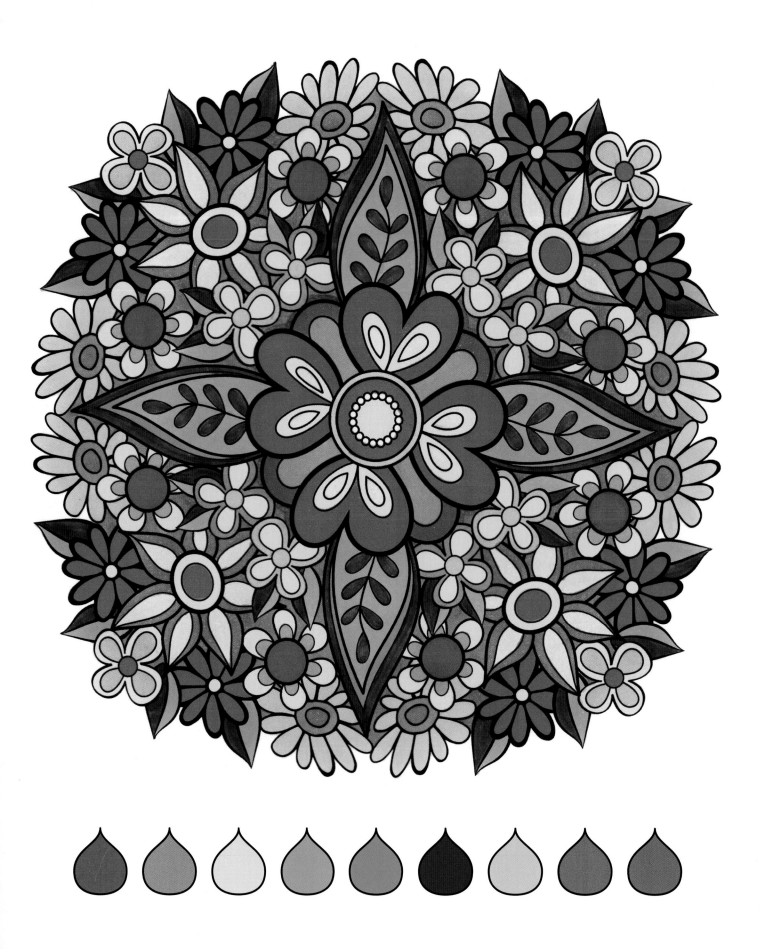

Love is a flower, you've got to let grow.

—John Lennon, *Mind Games*

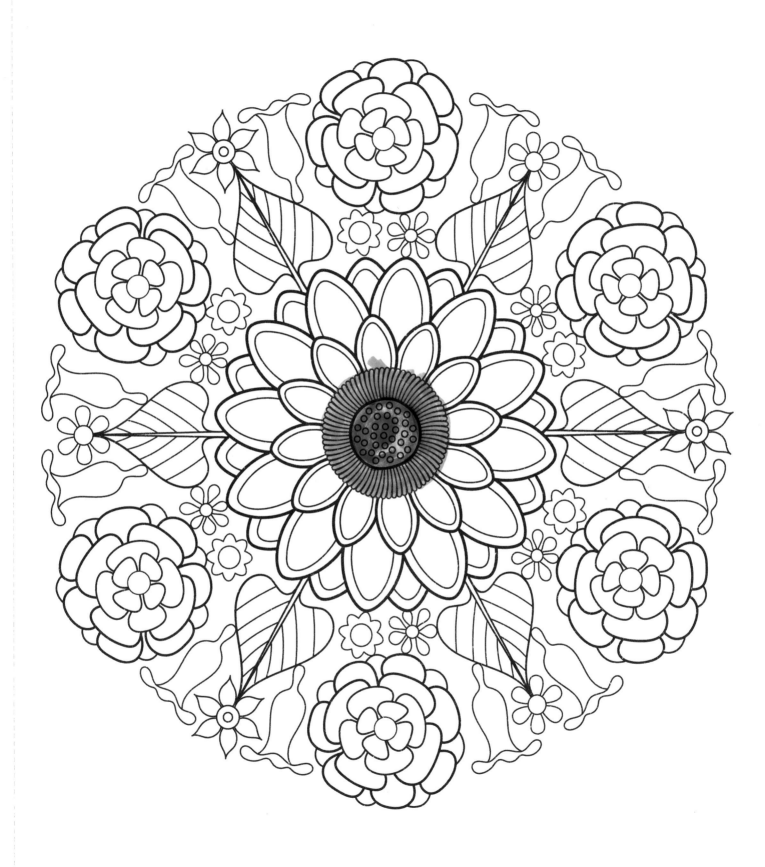

If I had a single flower for every time I think of you...
I could walk forever in my garden.

—Claudia Grandi

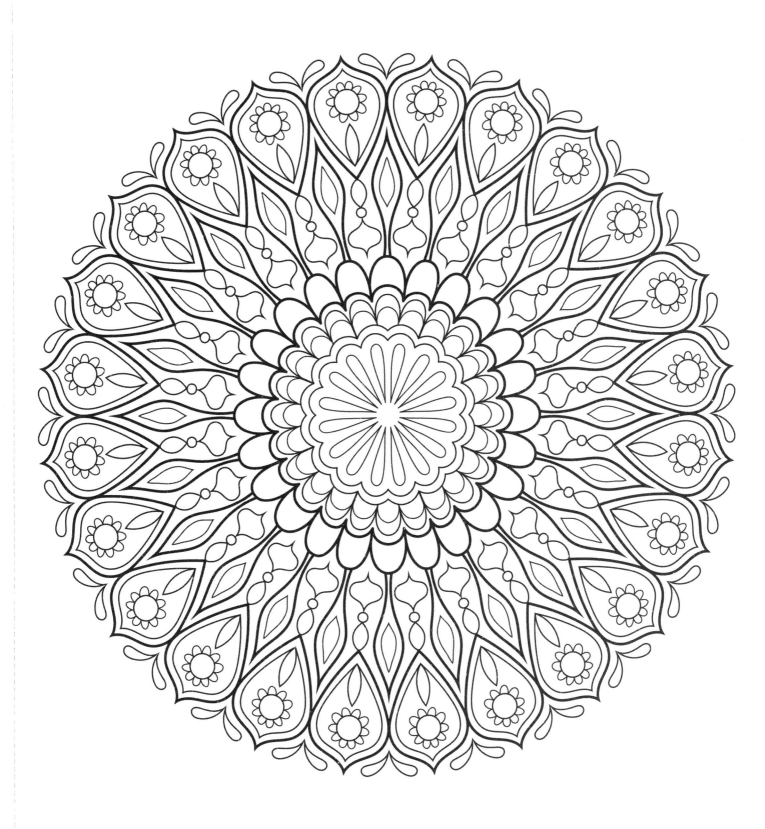

What is so marvelous about living today
is that it is possible to extend, like a
flower, spreading petals in all directions.

—Carolyn Kizer

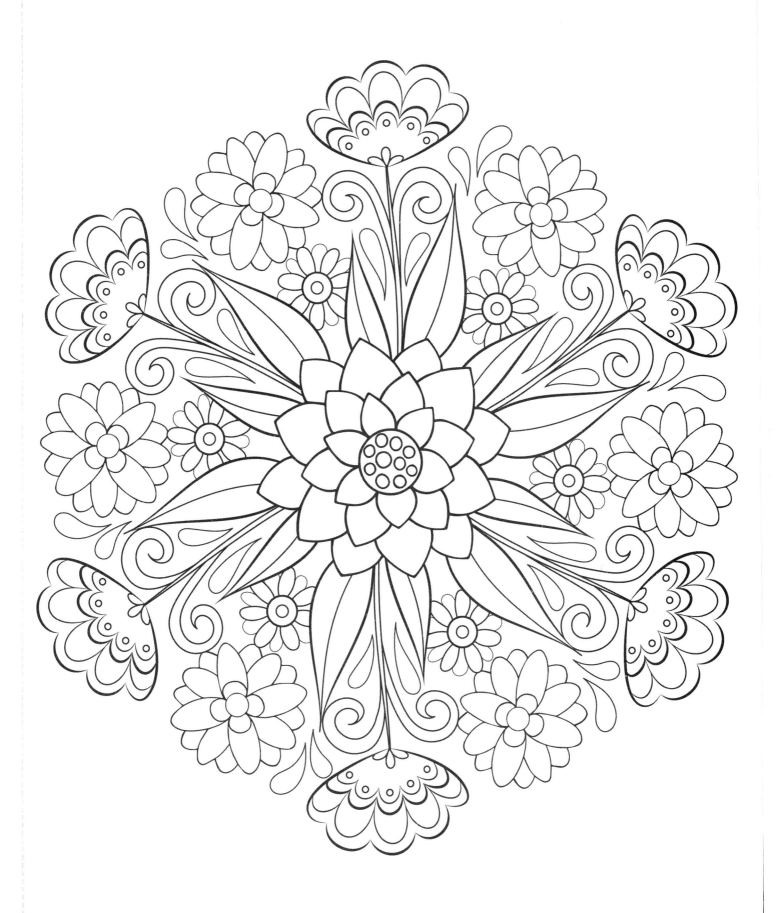

Normality is a paved road: it's comfortable
to walk, but no flowers grow on it.

—Vincent van Gogh

Let us dance in the sun,
wearing wild flowers in our hair...

—Susan Polis Schutz

What sunshine is to flowers,
smiles are to humanity.

—Joseph Addison

Life is the flower for which love is the honey.

—Victor Hugo

If we could see the miracle of a single flower clearly, our whole life would change.

—Buddha

The flower that blooms in adversity is
the most rare and beautiful of all.

—*Mulan*

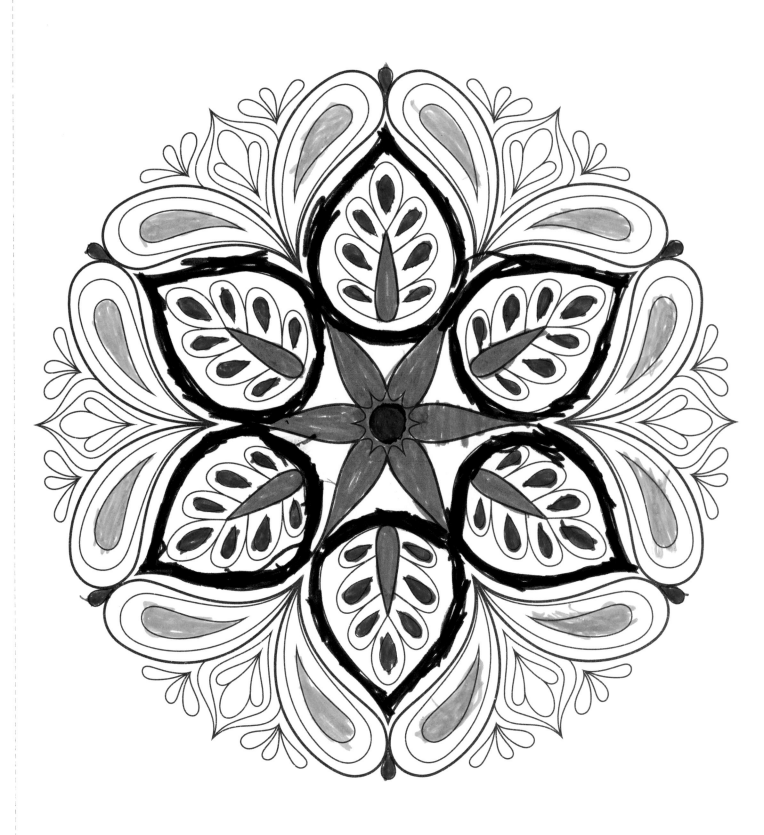

Every flower is
a soul blossoming in nature.

—Gérard de Nerval

If you look the right way, you can see
that the whole world is a garden.

—Frances Hodgson Burnett, *The Secret Garden*

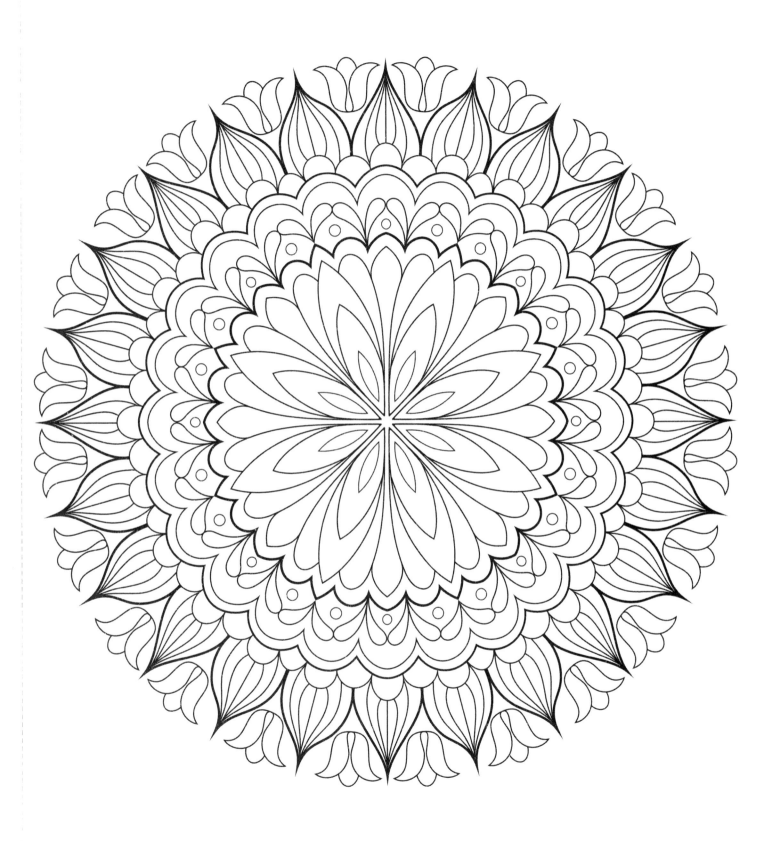

Because a rose can never be a sunflower, and a sunflower can never be a rose. All flowers are beautiful in their own way, and that's like [people] too.

—Miranda Kerr

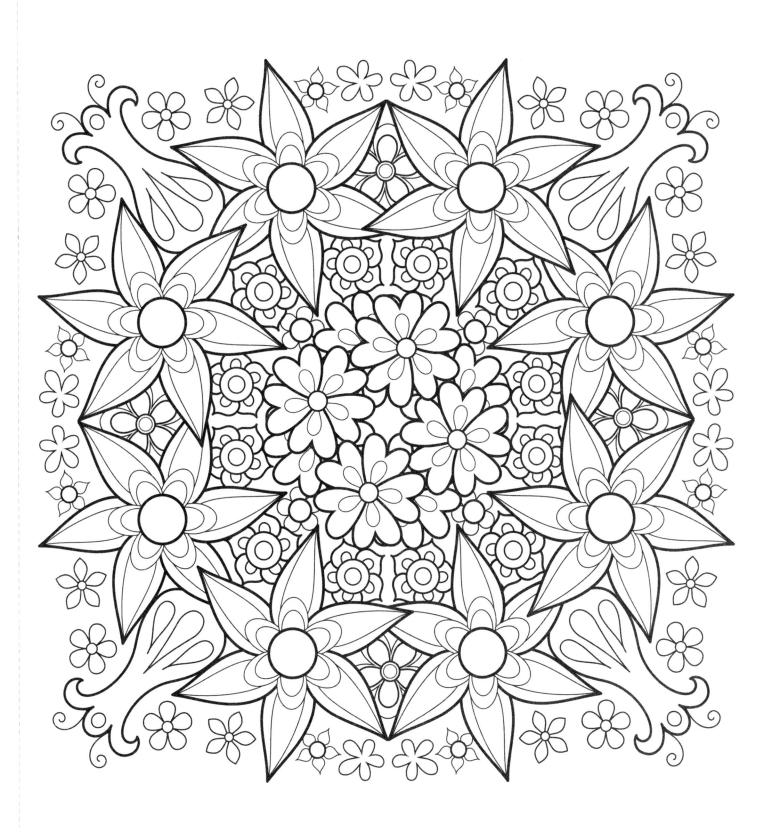

In the hopes of reaching the moon, men fail to see
the flowers that blossom at their feet.

—Albert Schweitzer

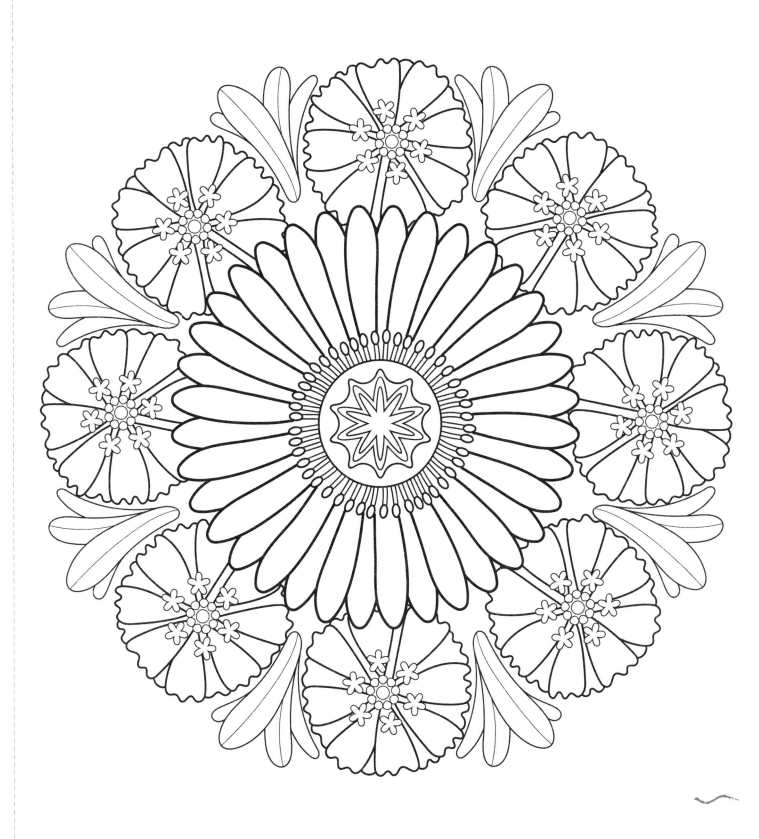

Whenever she turned her steep focus to me, I felt the warmth that flowers must feel when they bloom through the snow, under the first concentrated rays of the sun.

—Janet Fitch, *White Oleander*

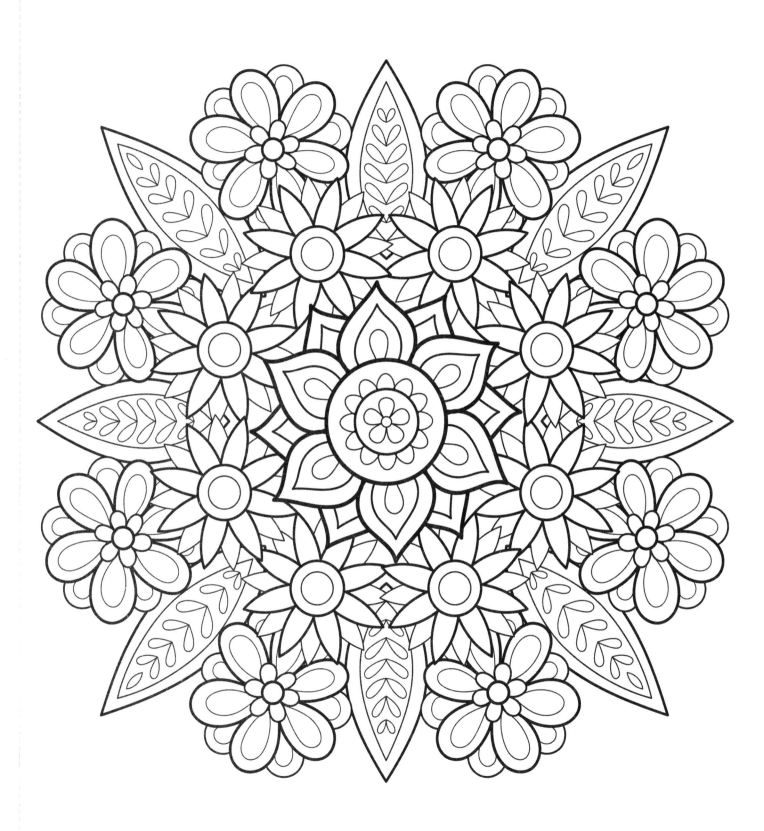

In joy or sadness, flowers are
our constant friends.

—Okakura Kakuzō

If we are peaceful, if we are happy, we can smile and blossom like a flower, and everyone in our family, our entire society, will benefit from our peace.

—Thích Nhât Hạnh, *Being Peace*

Don't let the tall weeds cast a shadow
on the beautiful flowers in your garden.

—Steve Maraboli, *Life, the Truth, and Being Free*

Deep in their roots all flowers keep the light.

—Theodore Roethke

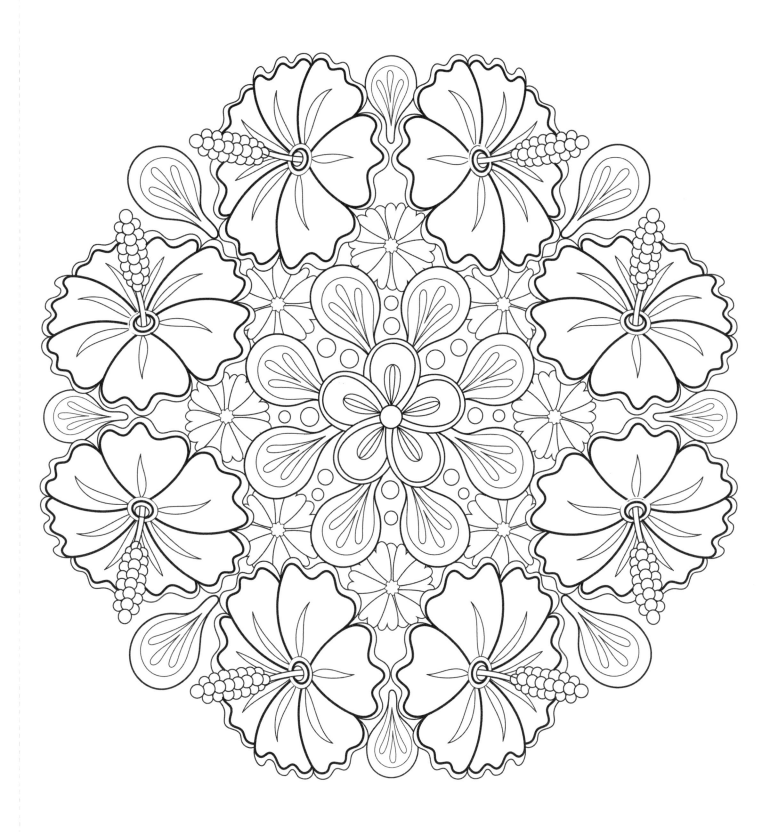

A flower cannot blossom without sunshine,
and man cannot live without love.

—Max Müller

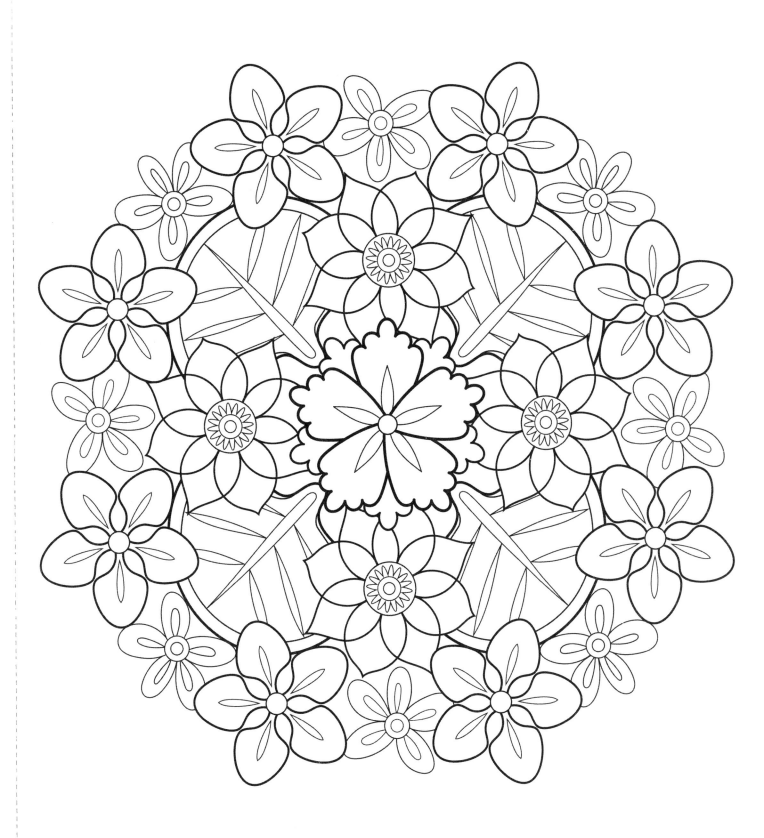

The flower doesn't dream of the bee.
It blossoms and the bee comes.

—Unknown

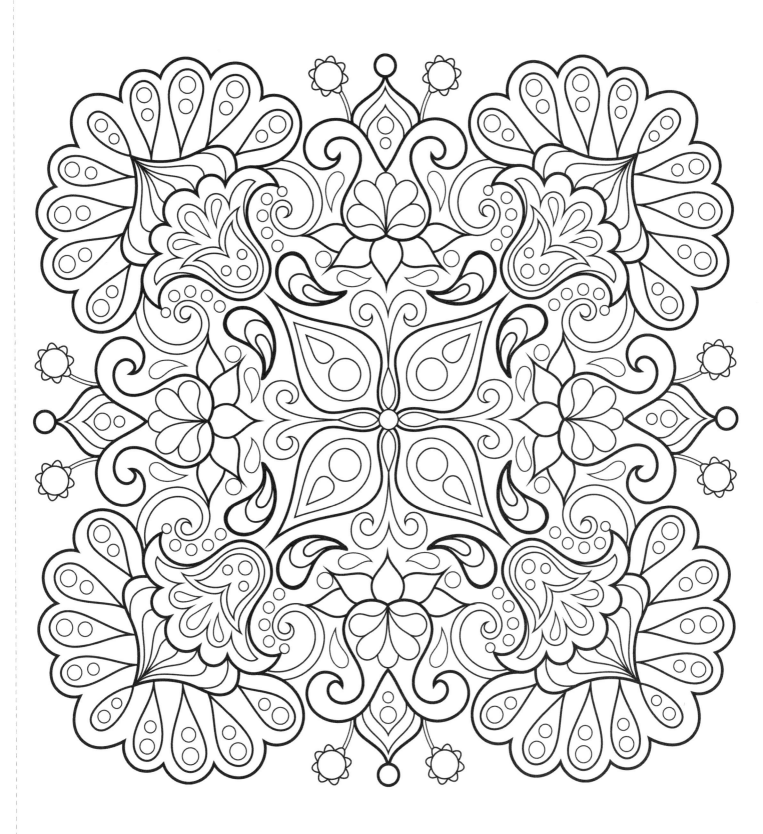

Flowers can't solve all problems,
but they're a great start.

—Unknown

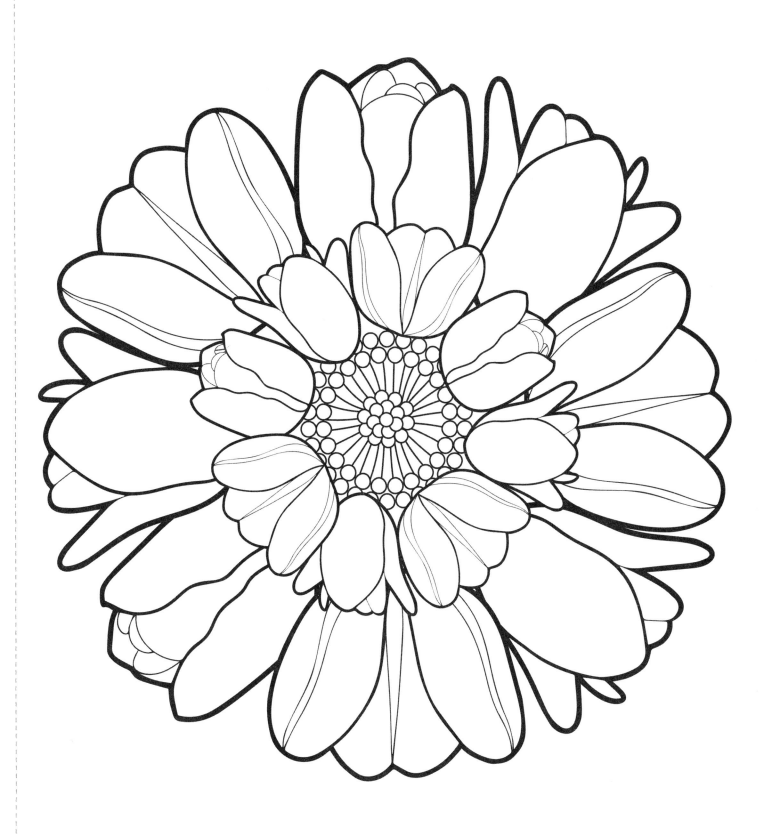

Happiness held is the seed;
Happiness shared is the flower.

—John Harrigan

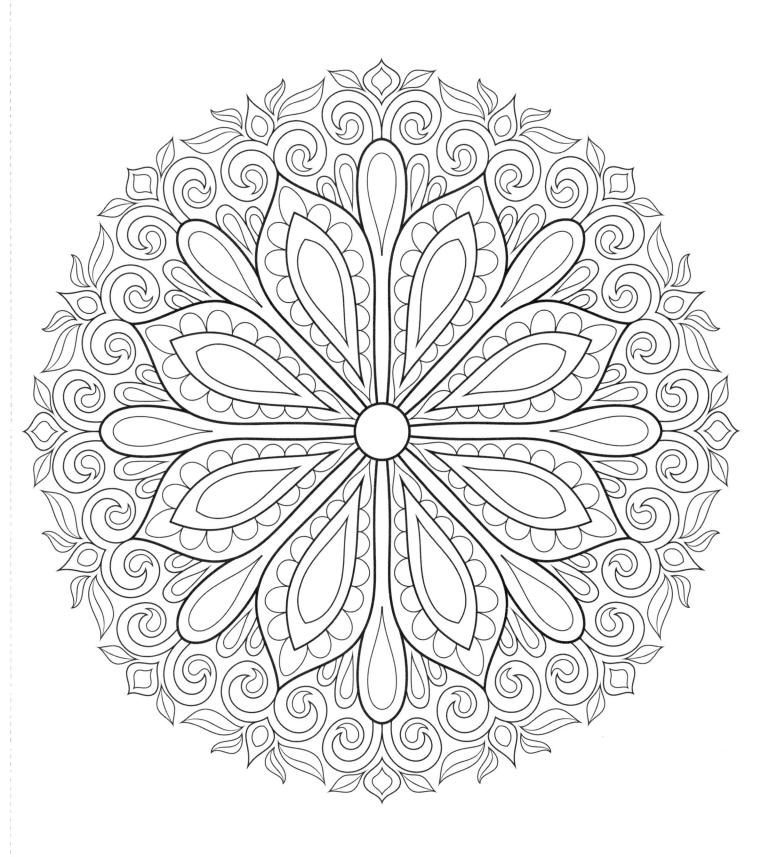

To plant a garden is to believe in tomorrow.

—Audrey Hepburn

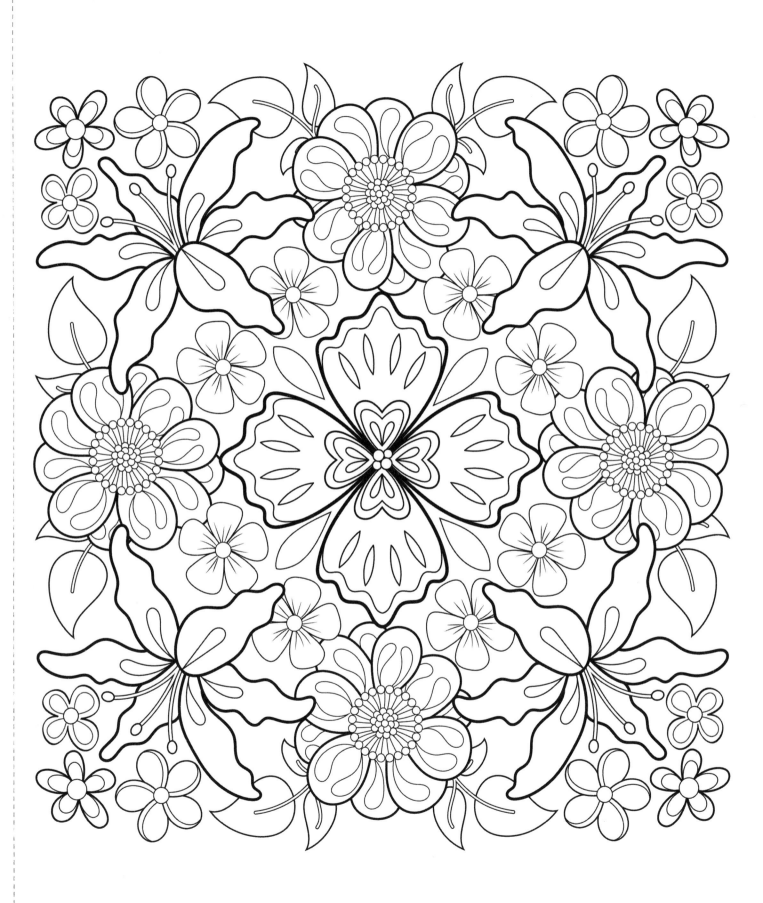

Perhaps, he thought, true pure love, like all flowers, flourished best with its roots in muck and mud. Perhaps that was a law of life that held everything together.

—Harry Mulisch, *The Discovery of Heaven*

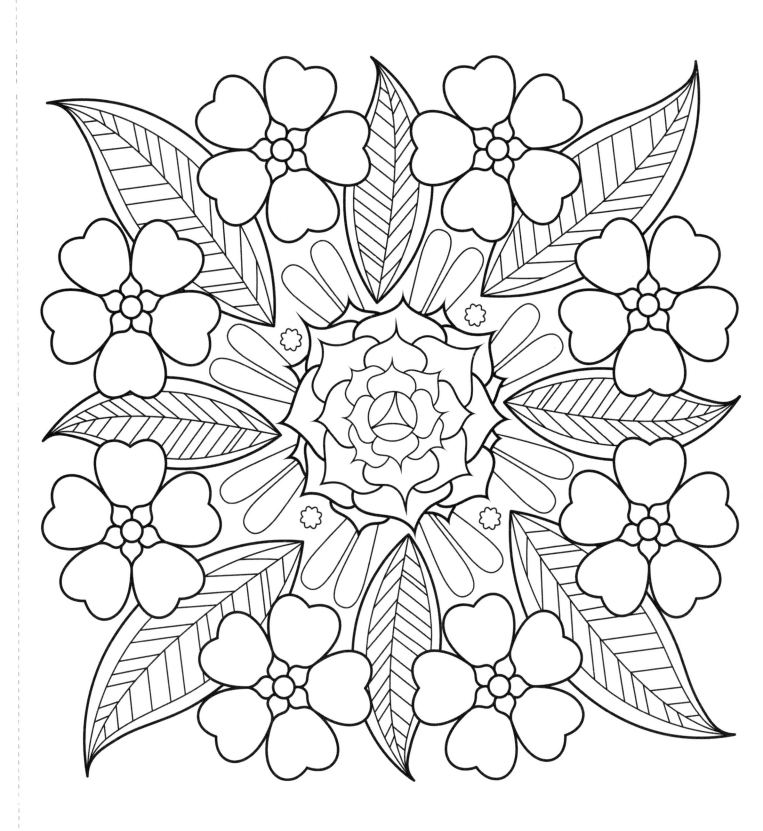

I am in awe of flowers.
Not because of their colors,
but because even though they
have dirt in their roots,
they still grow.
They still bloom.

—Unknown

Life is like an overgrown garden. You can spend your
time cursing the weeds, or you can work to pull them out.
In either case, the flowers are what matter.

—Sabrina Jeffries, *By Love Unveiled*

Get over your hill and see what you find there,
with grace in your heart and flowers in your hair.

—Mumford & Sons, *After the Storm*

And you will keep me safe, and you will keep me close,
and rain will make the flowers grow.

—Les Miserables, *A Little Fall of Rain*

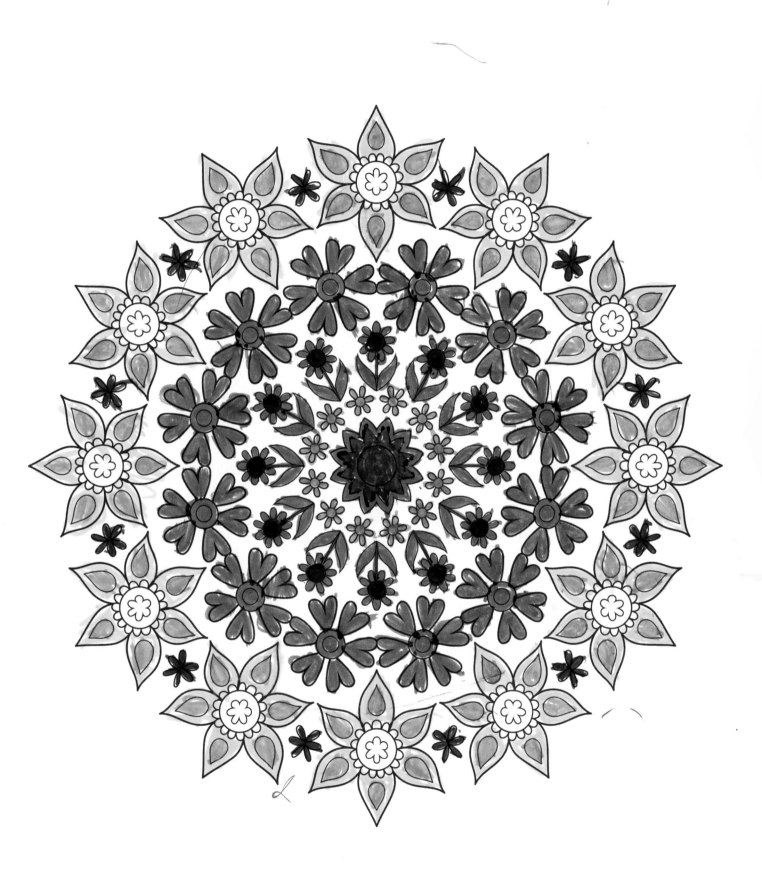

I must have flowers always and always.

—Claude Monet